The Life Expectancy of Wind

The Life Expectancy of Wind

Mardi Orlando

Order this book online at www.trafford.com
or email orders@trafford.com

Most Trafford titles are also available at major online book retailers.

Note for Librarians: A cataloguing record for this book is available from Library
and Archives Canada at www.collectionscanada.ca/amicus/index-e.html

Printed in Victoria, BC, Canada.

ISBN: 978-1-4269-1545-1 (sc)

*Our mission is to efficiently provide the world's finest, most comprehensive book publishing
service, enabling every author to experience success. To find out how to publish your book, your
way, and have it available worldwide, visit us online at www.trafford.com*

Trafford rev. 9/1/2009

Trafford PUBLISHING® www.trafford.com

North America & international
toll-free: 1 888 232 4444 (USA & Canada)
phone: 250 383 6864 ◆ fax: 812 355 4082

I ELEMENTAL VERSES

"Forgotten feasts of sensual beasts
Such long ago life spurned,
To bend to ghosts,
Raise your glass to a toast,
And watch the spirits release."

II EXISTENCE WHEEL

"The coldest stones of grief
Opponents weigh against each other,
In the game of culpability,
We seize anything but the truth."

III SEASONS OF RESISTANCE

"Let family secrets, Swirl in the crush,
Under angel skies she will cry to be heard"

IV THE MEASURE OF TOUCH

"Humanity's intangible masks,
Ghosts at a grave,
The writing of our human stories,
Our sacrificial pages."

V THIS SIDE OF SILVER

"Now this rhapsody of bitter-sweet crystallized memories,
Hangs like a low mist on the skeleton of dead trees,
And the pain within, sparkles like the last bright jewel,
The naivety of happiness known only to a fool."

I
ELEMENTAL VERSES

"Forgotten feasts of sensual beasts
Such long ago life spurned,
To bend to ghosts,
Raise your glass to a toast,
And watch the spirits release."

FURY & LORE

In the sun's naked flame,
The first angel burns,
From the spin-wheel universe,
They hurl toward earth,

Final surrender
of the endless return,
The earth's birth begins,
And so: Its first terms,

Wildly soaring as the
Tolling bell rings,
Inception or ending,
Unless the last angel sings,

Above crater-like maps,
As the searing scape turns,
Trespassing traps,
Fleeing angels squirm,

The bloody of wing,
Impale the spire and
stained-glass hopes spin,
Toward the pinwheel pyre,

The heat's heart-beat breeds,
In the age before beings,
Sleep angel sleep,
For the last angel must dream,

The Life Expectancy of Wind

Weave closed the black hole
of the unlikely womb,
Burn truth and light,
Into this spinning orb tomb,

With the hot breath of release
Whirling winds sear,
Twisting torment newborn,
As internment nears,

Shun the dark feast
while the massacre teems,
The fire-swirl swells,
Before the last angel screams,

Swing-stars spiral,
Cinders of past,
Ashes to ashes,
They yield to earth's heart,

Molten glass water,
Windows of light,
Reflect the new mortals,
Bound to the sentence of life,

Revolution of life:
The evolutionary churn,
Earth's cellared seeds rise
As the last angel burns.

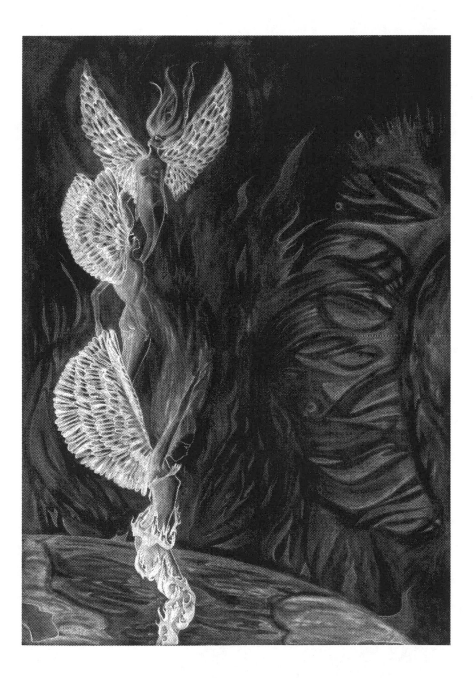

EVE'S SEED

The swirl begins, time's first child,
Pool-whirl-warm and windy wild,
Seeded and then grown blind,
Sleeping safely side-inside,

Ice-white sills spill icy winds,
Which blows and splits the blended twins,
Slipping slowly from second skins,
The double indemnity of original sin,

So stretched from sleep and coursed with life
The double-take and second sight,
Wait for warnings and relinquished rights,
And so begins man's tangled plight.

ON THE WINGS OF ICARUS

The plan is to fly free from the web of self-creation
under the vermilion flowers of superstition's reign,
on borrowed wings made by the man who deftly crafted
the labyrinth for a King at home in a kingdom of plays.

Dazed, against the golden decimals of the apple-red sun,
Diamond-dust fractions, refractions from One,
Bright light wakes your eyes in the tortuous skies,
as the moonless maze gravitates away:
Convex thoughts in minds concave.

The guise of equilibrium, balanced like water and stone,
The glass throne splintering its links, Seeded white light
winking defiantly into your silk-spun dreams;
the epiphonous stars courting intrigue and charming your celestial wings.

Rise until you fall, Reborn, Reformed to redeem judgment
borne to wiser rules and rulers fuelled by lesser gods of merciful duty
before the course of fire's fury that will pilot such fortuitous fate,
Resulting in your cerulean grave,
Life dissolves: Light in shade.

As the hourglass sands pour their sand-dune rivers
To sand off your branded skins, The triumph of the white lament is forever falling
into the gilded Aegean, But as an archangel bound to heaven's melting wings,
You will breed a new league of dark, before darker kings.

THE MIGHTY ROAR

The tree that steals the soil's blood,
The river that grinds the stone to shield,
The sun that burns its own heart to survive,
Polarity tortured within the wind,

The original letter, carved on a rune, by
The tempest tides of the new world, Roaring,
The first letter the sign that drove the words,
The Atlas Mountains that named the lands,

The primary colour that painted the past
on the indigenous faces of the children of earth,
The primal note of the hallowed bone
yielding to the hymns of spiritual birth,

The umbilical paste that bore queens and kings
who seized boarders as inventions for war,
Kingdoms created for royal gold rings:
God's rain will find them all.

This is the evolution of civilization,
Realms founded on the change of decay:
On the burning debris of Troy's deception,
Sabotage negotiating names,

Socrates' speeches freed to history,
ablaze in the pantheon of nature's shell,
Scoring the ego's of weakest man,
Dante's dreams, dissolving in hell,

The Life Expectancy of Wind

Explorers searching for the end of the world,
Making no peace with the earth itself,
Einstein's brilliance conceiving the bomb
Traversing the diagram of war… We fall,

Beneath the orbit, shaped by our shadows,
Wandering the hatred of coloured sands,
Pursued by the black lament of the crow,
and unable to show our hands,

This tempest of earth, bent from allegories,
Forming empires from children's lost dares,
Collective cones of coalescence created,
To hear the dying moments of Euripides prayers,

Thy kingdom has come and been undone,
Forgive us no sins and deliver us from peace,
For we have defied the mighty Roar,
Feed us our grandeur in pity's stomach of hell
For god's rain will find us all.

ENVELOPE; UNOPENED
(Noah's Lost Green Ark)

Essence strikes the law to life
and strips away demand,
The right to be,
such a small defeat,
In this bleached and broken land.

When a boat so built to start anew,
Paired up those that remained,
They would be left, trapped,
within earth's dark hull,
wondering who was saved.

That feast could feed a thousand egos,
Yet it starved a million tongues,
And now, captured in
such cold starvation,
They wonder if he will come.

Those so left must walk with truth,
For needs should summon
common man:
'Take away my mortal keel
For I no longer have my hands'.

But bile rises like the rains,
Of Noah's lost green ark,
And in our dreams,
As cruel seas rise,
Man must break more hearts.

THE WHEEL OF THE WORLD

Circumnavigate
the soul,
Round the skirt
of the wise-man's goal,
Climb the mountain
of stories told,
To the highest peek,
To watch the world revolve.

Twist like trees
in earths firm hold,
Reach wide earth's arms,
North pole, South pole,
Balance on the edge of
Equator's shoulders,
And dance at the middle
where lessons unfold.

Rise from clouds
that obscure and enfold,
Where on windless mountains
you'll feel no cold,
Spin on your axis
to centre's resolve,
For here my friend,
you will wake the soul.

DESTINE

Do you believe,
that we are tied by prophecy,
Denied by fantasy,
and then left alone to fight?

Link the fact,
that From beastiality,
Life became our legacy,
and the Gods felt no respite.

Do you believe,
that the Rafters of our dreams,
and the Foundations of time,
Herald the architects design?

Predetermined choice,
Foresees our very irony,
Free will, slave to sovereignty,
In mans lonely loaded flight.

Whom do you believe,
Would create and then deceive?
Search the landscape of you mind,
and take a moment to decide.

ARC OF THE COVENANT OF THE UNFLED MILE
(The Warrior Virgin)

The arc of Joan's sword
knights the heavens
burning with bohemian rhapsody,
The fear of false faith fermenting within,
The blade, layed beside us, that asks us
of our questionable lords,
Can a child speak to god?

Unequal in the fleshy grave,
Laid to rest beneath our holy hymns
And duteous tombs
that raise our script up,
Toward the angel skies,
Can god speak to a child?

Bequeathed with heresy, Before all, Betrayed
by the burning arches of earthly names,
All things sacred staked to truth,
As the bravest calls her last words to
Her almighty lord,
We ask,
Can a child speak to god?

ANOINTED

Silver pillows of sparkling pain
cushion aching thoughts,
The wisdom of the centuries bled out
by the satiated impurity of this anti-egalitarian fort,
Cathedral thrones of universal crust,
Echo hymns of so many untruths,
Sounds breaking through the crystal arches,
Crossing the hearts of irreverent wounds.

Could one good soul ease the earth,
born from these cribs of pious tears?
A chance to change lost probity,
rebounding upon the spines of these bartered years?

We congregate: Chastised disciples,
Celebrating conformity, Relentlessly unyielding,
Beneath crucified images of ancient fervour
that bloody the heart of this portentous building,
But cosseted by these arcane beliefs,
Where are truth and trust and blame?
Perhaps our sparkling silver pillows
Are simply to ease the pain?

WHERE THE FALLEN RACES HIDE

Listen to the whirlwind,
Close your eyes, Close them tight,
Look past the jumbled jungle into the
Desolation of desert-mind,
Search the planes of substance,
Across windswept sculptured times,
Explore forgotten sand dunes,
For the buried treasures you must find,
Look deeply into long lost past,
Where questions precede lies,
Don't be frightened by the tempest,
It's where our secrets are our spies,
Seek between the elements,
Of the wilderness deep inside,
Where the collective unconscious,
Plays with the wind in the night,
Tinkering with your dreams,
And teasing your peace of mind,
Ever wanting you to see,
Where the fallen races hide.

UNIVERSAL THEME

Dream the drought of nature,
See the fall of man,
Feel the laughter of a stranger,
and hope a dream is all I am.

Tomorrow,
Look for the brightest star,
Feel the peace of my presence
and then be as you are,

Shine white with me,
and touch the life,
You shall be with me,
but first dream tonight,

For I am the universe,
and I guide the way,
I am the trees and earth,
I am tomorrow and today,

I hold the wisdom pearl,
and judge the life you lead,
I gaze upon the world,
and watch you as you grieve.

I cannot save you,
but I can change your dreams,
It is so simple,
But first you must believe.
When you dream the drought of nature,
and see the fall of man,
You will feel the laughter of a stranger,
and hope a dream is all I am.

THE UNNAMED CHILD .I.

This is the untamed child,
The infant of unborn past,
This is the unshamed child,
Unmade future, Unremembered past,
This is the very beginning;
The light of good inside,
The basic sixth of sense,
Which ignorance keeps blind,
This is the unweaved thread:
Innocence before woven life,
Balance just the moment,
For this is the unmade mind,
You must seek this unnamed child;
You have to look to find,
For this is the unborn child,
You hold within your mind.

THE FALLEN LAST .II.

On the outskirts
of existence,
Through the seasons
of resistance,
Grows the lonely child
of our past,

He waits
for his time,
To leave this world
of a child,
To leave behind
His forbidden tasks,

For this quietude costs
Endurance rights,
Impassive implements
in worldly fights,
amongst his human cast,

Watch him stride
From light's infirmity;
Take abandon from
Dying eternity,
and embrace
The fallen last.

THE SON

I saw a man,
I saw him standing still in the night,
His silhouette absorbed all life.

I saw a man,
I knew he stared at me,
Although his eyes I could not see.

I saw a man,
Who felt so free,
Without words he questioned me.

I saw a man,
Whom I knew humanity could not understand,
And watched his soul dissolve within the land.

II
EXISTENCE WHEEL

"The coldest stones of grief
Opponents weigh against each other,
In the game of culpability,
We seize anything but the truth."

THE QUMRAN CLOCK

The night is upon us, the unleavened day allayed,
Adonis is the broken, the last statute portrayed
by the measure of the solstice mind
reflecting backward, under forward time,
Exponential internment, egested from elliptical ideals,
reasoned by reactionary designs buoyant on moral keels.

Quantum quiescence unbalanced, its' worth un-weighed,
Equality vacillating generously,
All those unquestioning, uninterested minds, unmade;
The elocution of the final flock?
Every quaver, a distillate of the disposable day,
Wavering, for the earliest change,
The formaldehyde child, imperfectly revived,
 On the last day of the fast of dissipated shame.

Aggregate intonations of dyslexic starts;
A mass unequal to the sum of its anodized parts,
The basic mantra chanting a regurgitative repetition of unwinding
demise:
All just letters, all just words, all quarantined in rhyme.
The twist of the helix reclining behind a correspondence of questions:
Sideshows just hitching a ride.

The gestures: The conjoining contradictory compromise;
The central subliminal sublimation surmised,
Its summation a guise for the quest of quarreled rights,
of which quotients are unconvincingly divided,

The Life Expectancy of Wind

Entitlement guided by heirlooms of history provided by
authorised greed for another foreign tide, resized and diced
with their own knives of concealment.

Conceptually conceived in the dark corners of achievement,
and aggressively agreed upon in the nature of bereavement,
Children loosely fall, into the arms of no negotiation,
Arbitration from inhuman means, extremes their negation,
Salvation falling from human grief,
Residue draining from the filtration of heads of state,
We wait, for a leader in which to believe.

We watch the waves of instability
forge the sires of conviction and the fires of the rock that
Surge with equanimity to fight for human wrongs,
The steel soldiers of this Pride:
The lions of the fall, face the force toward the final shock,
For we are The Institution, reaching for an egalitarian tile,
We are the Illimitable course, The source,
Existing beneath the purposeful pound,
Under the weight of the Qumran clock.

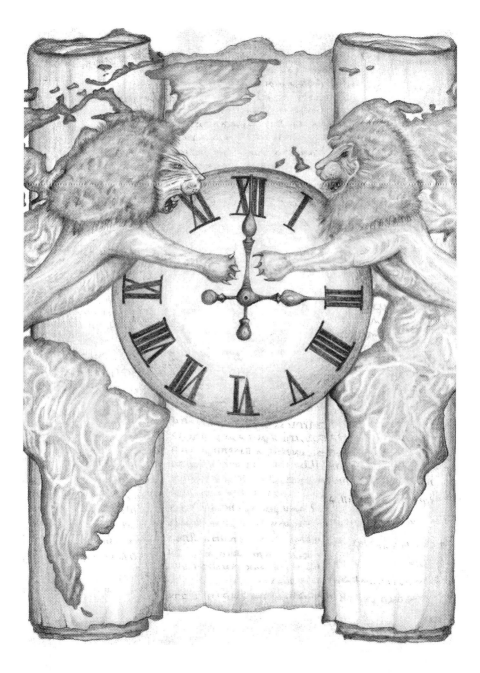

WALLS OF WORDS
(Auschwitz, Berlin, Guantanamo et al)

A dream of fear kept sleep most deep and numbed my limbs,
Too great to wake, not alarm nor urgent calls could shake my
deadened mind, my ache.

I walked a street that was grey with life, where stars of red caught
my eye and cornered spies, unhidden, watched, to calculate our
worth,
our lot, and note the names to call, to occupy the iron grates.

Locked and tall, the crisscross gates stand to barricade my way,
I turn, too soon, to catch a glimpse of hatred slip behind the wall,
I called, too late, to change the tone, I am judged by where I fall.

Now growing fear steals exits, bricks replace the open bars,
As our eastern glances plainly watch the backs of heads depart,
Separate endings revile repose, the spoils of war so neatly composed.

Iron guards replace the locks and strike terror beyond what I've left,
The last theft of life is its own freedom, the minorities understand,
This division designed by augurs and their laws, stealing our future's,
planned.

Our families thieved, for our beliefs, Mohammed's truth misjudged,
The scream is highest, when no one hears: These walls of words
adjust my fears, Defeat amongst my greatest peers, Loss, my greatest
cost.

I move away, unable to see over the top, I cannot see below or beyond,
No one responds, even defiance conforms to rules, Prisoners
because of where we stand, Criminals because of land.

We plan, we dream, but our futures are stalking our grief, Disbelief,
Yet history concedes, redeems, relieves, We are as confused as the people
who believe.

We all turn behind us, everyone follows, A thousand people just leave,
To go to ammonium's home.

THE SHOOTING GALLERY OF THE OLD WORLD

The palace shines under the skies of Palestinian days,
behind the sunbeams drifting with the human dust
of storyteller's tales told under the hessian roofs of
Merchant's stalls in a street of generations
that follow the ways that have walked these lanes
like worship jewels, To find the future still the same.

Hear the strike against scraps and glass as jewelers trade their craft,
Walk into the beat of rhythmic weavers tracing the colours
of hand-made carpets fashioned under the
firecracker-pattering of weapons traded and forged,
below the banner of American made,
Mapping the new world that refuses to change.

Arid lives of heady winds engraining the future
with the requisite pages torn from the exigent past,
A mongoose devouring its own fruits,
A child inheriting the rights of the last.
Piquant days, Revered, that graze amongst the fields of years,
Leaving patterned coils, Human inscriptions,
Carved by our own long race.

Under the same sunsets sick with rust,
Across the mountains that hear the call to prayer,
As the fight falls away from the bone, the unseen
maze gives way, and is left for the sons to devour,
The pulse of peace echoing in a mother's mind:
Words against monsoon rain.

Mardi Orlando

Waiting for the licorice night, to send to sleep the retribution
of insistent minds that wonder naught for the freedom of the west,
Nor for treaties buried within the dusty veins of custom
and the unyielding force of faith, Yet breathing just.
Jordan and Israel, A walk away, Sharing a sea that is dead,
Yearning against the landscape
Of the shooting gallery of the old world.

SCROLLS FOR A DEAD SEA

Above the swell of sapphire thoughts,
Under the blue-lipped kiss of the cerulean whorl,
Serendipitous slopes, fall away from me
licked by the exhaling tides of ancient seas,
long before deserts called your name.

Above the empire's mount that calls in the moon,
Under the elliptical course of cumulative seasons,
Follow the peripheral tail of forgotten quotes
along sand dune spines under sequined suns,
For looped fingerprints are stamped on us all.

Beneath the boundaries of ambient light,
Summon language in all its translations,
From salted pages scour your mind,
Of fire, of swords, of tongues struck mute,
For I recognize your past from here, too soon.

CEYLON WARNING,
(Village Morning Calling)

Over brooding obsidian river-stones:
Shrugged backs against the silver rush,
A roaring river charges, A tiger chasing its prey,
imbibing the thickly flowing, yawning blood,
before heaving into the past of day,
Oblique curses coursing downwards,
Dragging the riverbed free of sand,
Washing the wind in the torrent of tears
That Tamil Tigers have taught and feared,

Precipitated phrases caught in the surge,
Purged into Knots of current,
A herd circling the churning earth,
Before and beyond the last cascade,
that will take us to the end of the world,
And into the eyes of the children
that entreat the quiet sky of independence,
kneeling on the grass of indentured past
ready to fight for rights once known by Tamil kings,

Into humid quantity,
Into the dirty warmth of condensation,
The heat of the people wake,
Earthy smells rising in the residue of rain,
The appetite stirring, arguing, defensive,
Reprising cravings of misplaced homes.

The Life Expectancy of Wind

Wild and undeniably afraid, I am falling
beyond the world's edge,
I am charged and charging,
in this harrowing tug of war, before,
I follow the undertow into the past of day,
To be washed away in the Roaring River:
A tiger chasing its prey.

WHERE THE WIND-GULLS GLIDE

Water windmills stand still
in the silent skies,
Where clouds of silver stretch to see,
Where the wind-gulls glide,
They watch the cool and barren coasts,
To see the seals die,
And arise then murky dreams
of men effecting to be wise
Ancient and lost kingdoms,
Will give monarchy its rise,
And power in crushed countries,
Will make the people despise
Signs of sin ignored,
Will ensue then undisguised,
and the simple soaring eagle
Will become the symbol of a Reich,
Burning and parched lands,
Will hear the children cry,
Jungle soils rich with life,
Will covert the dormant bombs they hide.
Memories of peaceful dawns,
Will swiftly sleep with time,
Enlightenment and pride
abandoned by the scales of demise,
Seasons of old virtue
On which the world relied,
Will have breathed its breath across the shores,
And rolled out with the tide,

The Life Expectancy of Wind

Leaving then in its wake,
The clouds that saw such signs,
Which wish the wind-gull's wings,
Could make us seize our lies.

ROYAL DOUBLE

Royal double, beauty coiled,
Set to strike if recants are recoiled;
The coupled castration of serviceable moil,
Simple marks that bequest a royal,

Lost conquests for courtiers
like battles for soil,
Now shifting moments that
Shaft history's turmoil,

But two-fold opens at king's-a-coil,
The future quite fond of momentous spoil
and English words that tempt a mortal,
To cry out for freedom
In a moment less loyal,

That the question is not
What or whom is the foil,
But should the double be tripled
And bequeathed as a royal?

THE PRISON TREE

The legend walks
through the dreams,
of the cursed and haunted,
Prison tree,
Where swirls
the spirit memories,
of chained and
broken aborigines,
Taken from
their burnt ochre land,
and tied to stillness
by the white-mans' hand,
Dreamtime waking
to penury,
As link by link,
They are bound to slavery,
Snake-man curls,
around lost past,
White man: White crow,
and black black hearts.
Swim on songs,
that walk you free,
as ghost gums cry,
for those of the
Prison tree.

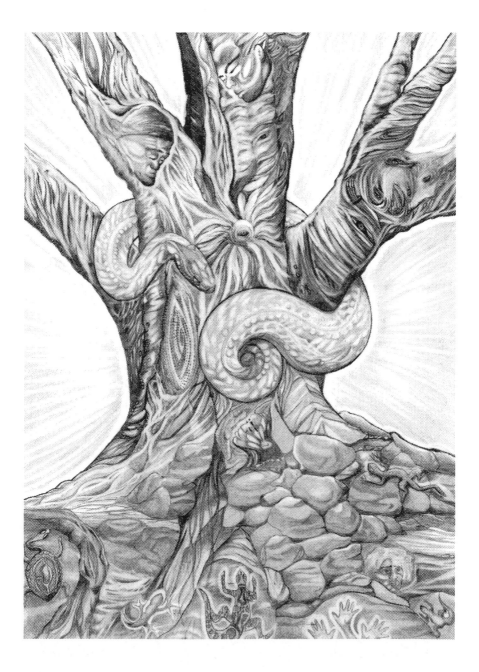

THE SEVENTIES SLIDE 1965-1974

At Seventeen we dreamed of living in The Yellow Submarine, we could Close our Eyes and Imagine Lucy's diamond skies wondering what Major Tom could see flying past the moon, But Sunshine Superman would find there Ain't no Sunshine in War, and too many would see the stars too soon.

We watched man land upon the moon beneath wallpapered ceilings made for the honour of movement by the kings of style; Flares pared with collars for royals, Within the circles of turquoise and orange, We sat beside our lava lamps taking Polaroids of pigtailed friends, wearing velvet as a testament to taste and trends.

Dinner parties were crafted amid cocktail rounds and hors d'oeuvre dips between the chain-smoked cigarettes of coral-stained lips, with odes to the Happy Days child. Immigrants were broken-in like an egg in a brawl, and were warmed to by the banquets they cooked us all. We grooved under the influence of granny's green stick, smoked in the Purple Haze, By the players of the 70's slide, We lived.

As Drafted troops were set astride, The Riders of the Storm performed under the compulsory call of the Vietnamese mind of uncultured war and the Cherry-red oxidized oxygen of the occupied flew in the haste of guns retroactively filed by the left-over jackets of those unbribed, as a million Cambodians died.

Fortified against the fall and rise of the government's totalitarian shake, The colours of skin and clothes and sin all strode the protesters stride, Anger surfacing on the art deco streets: Graffitied thoughts of conscientious objectors and those strong enough to be weak, All fought for the hors de combat and the people's irrecoverably altered inherent beliefs.

Love on vinyl, Twisted tiles, innocence lost on common streets, The heat of intervention abject in the contention of defeat, Our naive wiles bent, without resentment until, Returned, We saw our men, grafted by the very actions that sort out their cause, and a free wager was formed, We'll Paint a Red Door Black before we conform.

As compatriots fled war's heroin highs, lucid American juice, and Saigon cherry pie, Recurrent images forced the post-stress-disorder rise, and diners filled with the non-ambulant, the addicted, and the idle, All denied their community chest, Searching for comfort in the orally divine with the familiar words, "love you very long time": All courses eaten in the same small file.

We immersed ourselves in cubes of orange and brown, our 4-channelled televisions framed by lime green backgrounds of Jazzman as macramé pot holders, adorned with beads of love, jangled in the winds of change, while we made our way back from Delta Dawn and that Country Road that would take us home to the kings of style who lost their rights to a politically erroneous future that forced its people to fight,

Susie Quatro has finally arrived…

OF AMERICAN PERSUASION

Twin caresses
halve the mindless masses
that tow the course
of rules made up
by the Borrowing Four,
The permanent grin:
Glory, The famous-rich-win,
Pandora's pusillanimous pout
for America's smiling heads,

Requested sequestered doubt,
The engine that runs the mill:
The supersize of American will
that culls minds of independent thought
and corners minorities with black-faced lies,
Propaganda throbbingly supplied,
Stay quiet, and pray, you're good at that,
Yet salaciously overt, covert your thoughts,
Before you discover you are fighting
another pointless war.

LAW OF MASS ACTION

Winching thoughts from idle courts, Conversations
lent from the minor chord of justice, which cripple
the conscience constantly.

Legitimacy, jaundiced by contrast,
devoured by the censure, sold to those feeding
off the gloom and precipitous purchase of pioneered paths,
probing for the unrequited days of Cain
with blame filled eyes,

Enabling the sutures of blistered tears to sew the names
gone before, into badges worn like lesions, and so, the
justification of form egregious, Decree for lost devotion,
sworn over injustice's allegiance,

Ablutionary revolution will seek grievance warmed
by retribution, solutions sharpened on the knives
gnashing beneath the social cement where entombed
Consciences slumber before hearts beating with
draconian measure sum the old and new,

...just please, close the door behind you.

PRELUDE TO WAR

ALLAH IN THE HIGHEST	AMERICA, AMERICA
Wind your tendrils	Smoke-screens and tactics
Freely around me,	Secret wars we wield,
Wind them tight so	Flashing screen images
I can not break free,	Which ones are real?
No room to express	Cover-ups and questions
No room to see,	Spin our rotating wheel,
Only thoughts where	Fleeting thoughts,
What I'm taught is all I feel.	What I'm taught is what I feel,
The enemy out there	Which enemy out there
Is an enemy too real,	Is the enemy so real?
Listen to my heart	Listen to my heart
My mind, my ideal.	My mind, my appeal.
Wash them clean	How did our values
Of visual need,	Become so unreal,
Cleanse them of sin	Dancing their dance
And their sickening greed.	In the court of King Lear?
The life I've sworn to	I'm confused and concerned
Is cold, hard and sealed,	With my government's zeal,
I inhale the future	Is more destruction
Of my willing zeal.	A reason to persevere?

I call to arms My explosive shield, One must destroy In order to heal.	Called to arms are The camouflaged green, Can anywhere really be The land of the free.
I see no peace In the buckling steel, But I follow belief And before Allah kneel.	I see no peace Beyond bombs of steel, I clasp closed my fists And fall to my knees.

THE MINOR CARNIVAL OF A MAJOR PLAYER

Gold demons of oblong strides, Stake distance on curiosity,
Wiping dry, loquacious buyers from inside hives of riddled blame,
Circus currents quick with circles, confound numbers numbed,
Caving sands of rising markets: Hoops spun toward a nail,
until cravings waste this tender phase and the hourglass stands empty.

Reflexes ineffective for robots and skeletons and those without
patience,
Channels funneling capitalist privileges: Legal tender left to right,
The fight for consumerist monumentalism sculpted into Four-bed
houses, Vacant, Unsure where rollercoaster rides recline and declining
trade resigns its raid under a stock market free-fall: Games that play
themselves in name.

Complacent, coach-whipped brains of limbered quotations: Answers,
from other peoples declarations, Irony egested from Economy,
Realms ruined on less, Recession breeding regression, free-forming
facts for all that is all, effecting our effusive stall, Failing to understand
why they are taking away our land and wrenching our promises with
them.

Capitulation to a capitalist nation promoting cupidity as the ideal
notion, Greed superseding the family trust, The seeds of material
worth dispersed into accumulated means and all things that represent
your Midas touch, discussed over you 4 star credit-card lunch, Like
sheep, Undigested before wanting more, Free money will eventually
cost you everything, Grief is for you to keep.

GOLDEN LIGHT
(Chang Mai Accord)

Buddha's golden image shimmers
beyond the dawn's mirage,
Swirling blood-orange children,
Peripheral patterns inhaled with sunrise,
Tumblings of the collective heart
Quiet after night,
Promise rising with incense ghosts,
drifting through the streets of nascent heat,
Fragrant ashes that fall like orchids,
Cresting necks bowed in belief,
Paper umbrellas twisting forever,
Worship wheels that never unwind,
Smells warming in the somnambulate sun,
Yesterdays fruit softening forward,
Into the insouciant, hazy sweetness,
Into the offerings,
The lull,
Lured to harmony,
Air smoldering with prayer,
Where throngs are decantered,
and the borders of heat capture the colour of days:
Honor's kaleidoscope funnel of
lingering patterns looped with change,
Where spirit's aspire in quiescent minds,
To seek the treasures of luminous life,
in the dusk of
Buddha's accord.

RUBY'S PROMISE .I.

"Dragon fly," she whispered
from her humming heated heart
on the eve of her awakening
in the cradle of Brahma's arms,
Her golden brow surrounded
by the halo of the sun,
Rings of hope evolving
from the wonders of the past,
The thousand-petalled-lotus
Spinning fortune in its wheel,
Winding memories of her future
within its golden weave,

Bejeweled inside the ruby realm
on the edge of divine gift,
His third eye calls upon her soul
to transcend her worldly drift:
"Lift the golden dusted nebula
that clouds your dying star
and move beyond the human coil
that wraps your sari heart,
Shed this light across your
other worldly course,
Sense delights arcane to you
and curl inside your golden task,
The dragon flies will find you
In a promise to the skies,
Orbit this new wonderment
And inside my mind so rise".

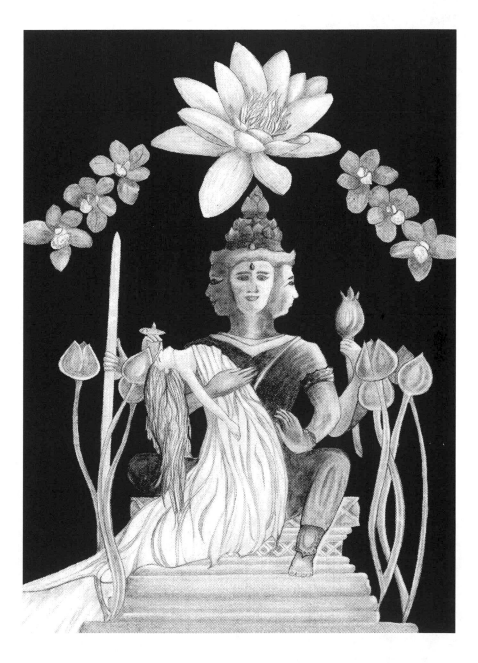

PROMISES OF THE SKIES .II.

Seasoned corners
raise earth's fine dust,
In measure, to swirl,
Like golden doves,
Love's secreted circle,
Her will,
within the symbols,
Perched, Perchance,
For the distrustful
promise of change,
A pledge long gone
and thus so shamed by
The blinding rays of hot white sun,
Mirrored from the
golden coins of faith,
Echoes by stolen love.

Transcribed,
Beyond transcendental motives,
Beyond the transpired scribe,
The hidden ridge,
The soaring wings
of the mind,
The simple patterns
traced into the wings
of the dragon fly,
Humanity's course,
evaded by man,

Mardi Orlando

Barely breathing
under the halo of saints
and the orbit of time,
Beneath the drift of ill winds
and deserted belief:
Forgotten promises of the skies.

THE WINDCHIME HEART
(Indian Offerings)

Long grass layed flat
By sleeping heat and oceans of breath,
The setting sun:
The exultant prince dies young,
Casting shadows
of stone motifs of unshook hands.
Tie-die, Cast,
Like scrunched up names,
The shamed, swirl deep below the waste,
Where silent heat,
Shifts wandering dreams,
and muddy streams wash
the souls of those out-caste,

…and where I hear the wind-chime heart.

DISHONOUR ME
(Love Without Honour in Jordan)

In tepid waters her image shines, Her coldest whispers
washed in silver shadow, Weeping where ancestors
are known to have taught the gestured minds, Red of memories,
Soaked in rebellion, To stretch the stories of the mind's terrain,
To commit their souls to ripple like rings; resonant like rain:
Nimbus coils augmented by the surface of the sun where innocence and
family secrets promise no awards for those of diverged love,
Crystalline and icy cold, her white-light whisper sings:

"We are the female children of our father's graft,
who cast our lives into Koranic Law,
We are children fallen to unfaithful love,
the children without honour in war,
Cry for us, for our souls are gone
and our names so taken away,
For Muslim hearts must collect this blood
to gratify their shame.
We are forever the unsaved."

The stone of the water's hold, cast between converging currents:
The heir of the Kingdom's robe, Where souls collected under the
blackness of tide, wait until the water snakes unite, glistening,
as the staff of life, entwines their stories, weds their lives,
Each wave, a charge, Each shadow an image, Each cry an echo
drowned by a father's law, Each icy whisper holding the hearts of
grief where ancestors crystallize the prayers of nameless girls
who will forever sleep beneath these ubiquitous stars.

STEELY LONDON

The steely light will wake us
to London's
Calling Game,
Welcome, treasured hurts,
welcome to our nave,
Mutual memories
of homeless lands,
and travels of the mind,
open like a dowry,
to wed the gun-grey sky,
Where iron posts jab our veins
and fill us up with mud,
to block the seeping stains,
And strip us of our blood.
For those of
London Calling,
Abstinence thaws the mind,
and feared flickers of recollection
revive our worn out lives,
Our grimy windows face the past,
Inside the cold is hiding,
Weaving in and out of shadows,
Too much light is blinding.
We call the days with prison strokes
like sewing up the time,
listening for our future,
in the splintering rain outside.

DARWIN'S WHISPERS

Golden palms ride red ochre roads,
Drought drinks dry the soiled souls,
Memories waking of ancient thoughts,
The dark man's dreams sold and bought.

Sunrises blaze on salmon gums,
For the daylight moons and midnight suns,
As time turns back to recognize,
The simplicity of its sums.

Silvers, greens and black burnt trunks:
Wastage wailing from thirsty stumps,
Withholding secrets of land's lost kings,
Black fires burn to sing their sing.

Termite towers of treasured time:
Gravestones growing from broken past,
Like human sculptures; first and last,
Created from earth's dust.

Whispers swirl in the sunset's sea,
The rivers' secrets safe with me:
As wordless stories wind their wind,
Twisting veins across deserts minds.

The Life Expectancy of Wind

History snaking beneath forgotten lives,
Where wisdom wizens its wounded miles,
And ancient dreams wake to find,
That all is not past loss.

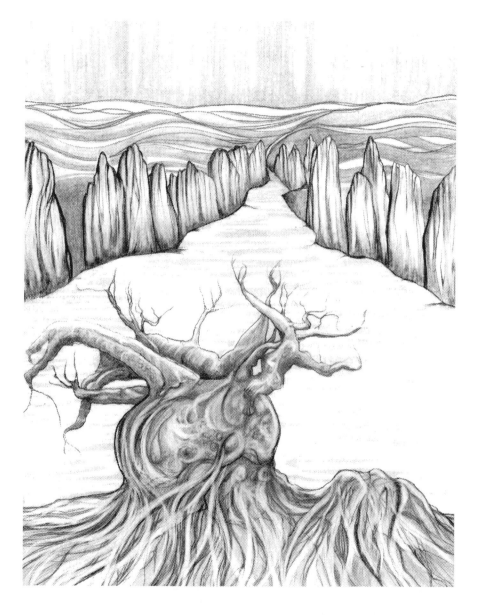

III
SEASONS OF RESISTANCE

"Let family secrets, Swirl in the crush,
Under angel skies she will cry to be heard"

IN THE COURT OF MUSSOLINI
(The Libran Child)

Born to:
Mother Macbeth, sister-no-nickname,
and Mussolini dictator father,
Grandmother in love, not of me,
4 cousins after Baby Jane cried.

Doctors, decisions,
illness's, operations,
Hospitals, cold for small children,
Jacks in the ward,
Real pig knuckles from nanny,
More slippery and harder to play.

Balnarring holidays
of childhood limbo,
Amusement, the circle of fear,
Inevitable costs bringing
a mother to task,
to exorcise sister-no-nickname.

In the court of King Lear,
Violence in two ways,
Mussolini's ideals live on,
Mother works nights
or with her lover,
Blackest nights spent
Hiding from home.

The Life Expectancy of Wind

13 years and counting.

Macbeth mother,
Devoted to instruction,
Takes sister's 17 year old boyfriend
to introduce him to marriage,
And so, under Glenferrie street lights,
in a car shared by us,
She turns him into a 'man'.

School misfit, unattached,
Words listed in diaries to come,
Discovery of freedom in anorexic theorems:
Geography of the mind,
Antisocial studies,
Stravinsky's syncopation,
Borrowing balance that was not mine
to share.

New step-father the son
Macbeth's 34 to his 21,
'Don't Trust Anybody' we promised
And meant it,
In the darkest night of Christmas Eve,
He hid and watched
us in bed.

Kick me clean toward centre,
Stand still until you fall from force
as mother-witch casts you from home,
Stranger yourself,
The universe indifferent,
Fly me quietly toward the moon.

Escape the circus
at 16 and more,
for an endless clown
of mistakes,
Trust and consequence,
incongruous truths,
No gold stars for first lessons removed.

Use-by-dates, endless,
Weighted scales unequal,
As men extract what's left of your soul,
Gold roses – just painted,
Emptied minds unrelated,
Only lend what collateral allows.

Forever-nightmares rebound
across decades to follow,
Peace Imprisoned
In dreams that won't come,
The diary, the dowry
to take to your husband,
A hope chest
Of secrets undone.

Medusa's cool warning:
Mother's blood grows a life
To carry the child to its very first home,
The fatherland may rest violence
Upon their uneasy hearts,
but truth will form all on its own.

COME WITH ME

Come, come, come tonight said her eyes so hollow,
Come, come, come with me where no one ever follows,

Forward into blackness and backward into night,
Come, come, come with me where no one needs to hide,

Come with me to this tunnel door where no light survives,
Follow me into this black, black night to find it open wide,

Come, come, come with me before the night declines,
To find at last, when you reach your past, there is no door to find,

Come, come, come with me, I can change your fate,
Don't let the fear in my eyes tempt you to escape,

Float then in the languid light, and leave me for your dawn,
You'll wake to dream of my aching eyes into which you'll always be
born.

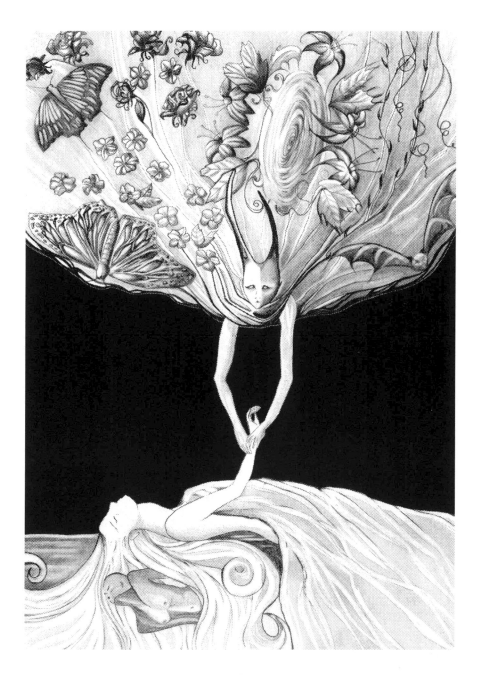

MR FIELDING'S BACK YARD

Green liquid light from summer skies,
Falls through the tall, still, liquidambars,
Seeds from palm necklaces, fall, plinking,
Ping-pong delights for female figbirds,
Beaks popping the hard red shells,

Blooms of ruby-red hibiscus dripping
colour to the ground, Air-orchids fanning
Maori Hakka-faces, Twisted amongst black boy roses,
Gaping from passion-fruit vines, their
Purple pods, promising yolks of sour-sweet heaven,

Fig-tree canopies bending arms
Toward green grass smells,
The blood-red dance on the mulberry tree's boughs,
Stains to last for life,
Sour smiles of unripe plums vying with
See-saw dares for lemons,

Orchard-apple-cider, fizzing like child's delight,
Sweet smells of scented jasmine,
Permeating the stories told under the willows,
amongst the music of honeyeaters,
Plying nectar from their pollen gods,

Tea parties with Noddy, Big-ears and little black Sambo,
Hugging our golliwogs that nanny had knitted,
Under shaded pockets of blazing suns,

where fantasies came to life as the princesses of
Valda Grove imagined dreams in summer twilight,

Wandering down the secret paths,
Screened by mirrors to capture the stars
and reflect back to autumn and spring
before the sunset sky slips below
the last leaves of the silver birch,
and into childhood,
where summer forever swims.

THE COLD LIGHT OF DAY

In light's cold day, how does it feel
to watch your child turn so slowly to stone?
In your corner, off-centre, is ignorance bliss?
Am I missed? Do you seek me in dreams?

Under protection of this formidable ruin,
Forms, fallacious, are growing unseen,
The black crow is daunting but I'm not planning
to heal, Why is ice so different to snow?

Do your fractured denials offer you peace?
Does my life prompt memories of your own?
I'm so alone, but soon, I'll be still, I expect,
And then, I, will reject you.

Now I'm bruised and confused and broken as you know,
In my grieving monopoly I just let the time go,
For I have lost all the reasons why this was my home,
Is it so much simpler to leave me alone?

Will you answer your demons or lay injured by mine?
Who will survive long enough to revive?
How does it feel, to stop looking at me,
to not see, let me harden like stone?

THE ANGEL'S KISS

In the cool,
calm mist
The devil and angel do kiss:
Creation bequeathed
unto me,
Where unborn stars
Glimmer
In the darkness of grief,
As my soul's solemn
midnight
Pulls me free,
Inchoate dawn,
gentle in its seed,
Endeavour's to appease,
the balance
of trust and tryst,
But the insolence of angels
abandons mortal needs,
my succours, my cast,
the universe, Me.
Immutable future,
Indicted past:
Duteous horizons convene,
In the stretch of ever after
They offer their decree,
Solicit universal creed,
Made formidable
by the last bastion

The Life Expectancy of Wind

of benighted thieves.
Thus,
The icy cold lake,
accepts my accord.
Turn full fold
and forward my dreams,
To a braver soul,
To a more generous being,
Who seeks not the angels kiss.

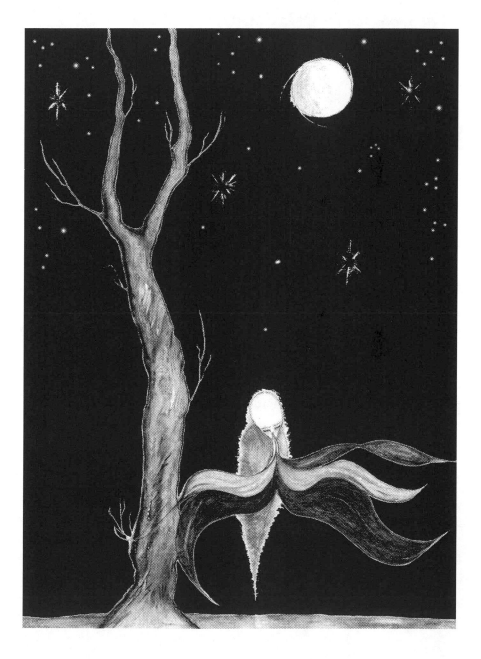

THE SUB-STATION HUMAN; LIMITED

Immobile conflict: the temptress of knowledge bound tight;
The light that shines upon obscurity
that dims as I turn my mind -
These are the limits of perspicacity,
the borders around which I crawl,
Lured and then thwarted by the measures and their flow,
Dark Boundaries to tumble up to, and out-call,
To sidle beside those margins; the limits which divide us all,
Only to grasp at the perimeter of the note's fundamental find,
These are the nights of the mind.

Hard corners which crowd the conscience, and fail the flailing muse,
Binding the conscious capacity,
Confined by the crudeness of truth,
Restricting knowledge & prime numbers of kind,
The inexhaustive incapacity of an inexpandable mind,
The sub-station human explores only to find,
With more information there is still more to find,
The ease of ordinary unable to augment an unreasonable mind,
The ultimate surrender of cerebral ties,
These are the lights of the impossible find,
This is the world which I fight.

THE CURSE

In the foul breath of night,
Witness the curse of my mind:
Flailing black limbs,
And the stare of blind eyes,
Malignantly floating,
Craving the dreams in which I hide,
Creeping amongst my blackness,
Exultant with that last goodbye.

Memories, primordial,
Screaming in that fragile night,
that stripped my courage
and stole my light,
Each insidious second,
Absorbing my mind,
As she searches for a soul
Which I fear may be mine.

BREATHE THE DREAM

Night sweats form from coiled blackness,
the tunneled visions of screaming dreams,
Subconscious subways of subterranean sludge,
seeking to drown the unsoothed day;
To suppress the tremblings of wings of vultures
Backward beating into night;
The turgid waters of memory's spank
subverting the hunt for prey.

Reason rotted with purple liquor,
Solace asleep in the eternal abyss,
My flaws lured under my sinking name,
My own fears poisoning my will,
Implicit hearings of shrieking contempt
Shattering my once protective pride,
Distrust regurgitating its privilege, in the undercurrents,
in the surrender, in the forgotten grief of quiet nights,
Where the ambivalent depths of unwanted truths,
frighten the children who have fallen inside.

The body numbed from obsequious dew,
Greedy dreams tease the night's crusade,
Whose dark seeds grow without recant,
Hypocrisy to sublimate the damned, indeed,
But the taunt is ubiquitous to the insomniacs needs,
For the need is the dream and the dream is the need,
Breathe, breathe, breathe to dream.

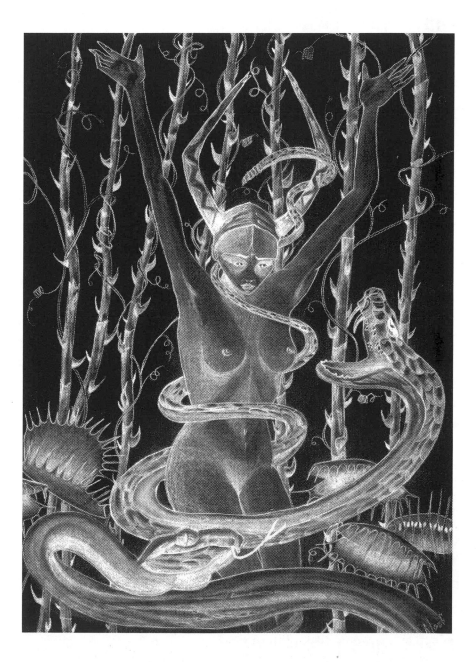

OPIUM JUNGLE

Ruby raw opium warms muddy blood,
And skims the milk from effervescent eyes,
Warm baths of words unearth the gas-masked mind,
Spellbound sounds in winter's eyes,
Intoxicated by luminous lines
running the grids across the world's divides,
The rules of maps engaged,
Engraved into earth's golden plated rind,

I can see…
Season flowing from the wing'ed seeds of Plato's time,
Flights of skies and seas of fields,
Forging roads into the cream of reason,
The runner's branch of buds reaching,
Fingers caressing from edge to edge,
Searching the sybaritic songs for treason
veiled by soaring longing,
I can hear where I used to belong,

Ignorance is not innocence and will be tested
by the sap of the bleeding child,
Pledged to guard against moral wrongs,
I feel strong, I am inspired…
Plagues melt into velvety smoke,
warming waxy truth from minds
wild with the weighty purpose of life,
wilted by the somatic suppositions
of ill will,
I feel … alive,

The globe of notion blending nations,
Crackle the branches of thought,
In my opium's den, in my spirit filled lust,
Floating fluidly, in my illimitable whorl,
I sense The honourable; The opportunity;
The transience of infinity; and the coil of
re-creation in the essence of the furl,
And now I know…
I can hear the world.

EMOTIONAL FLEET

Augur for anger,
Anger from need,
Need from desire,
Desire from greed,

Self doubt from abandonment,
Abandoned in retreat,
Rejection of emotion,
Self-hate in defeat,

Worship of devotion,
Devote to blind belief,
Obeisance to confession,
Absolution complete,

Fanaticism leads obsession,
Blooming from cold seeds,
Fever then from fervor,
Judgment from conceit,

Apathy from convention,
Voiceless as they speak,
Establishment unchanging,
Proves opinion effete,

Fascination with fear,
Absence from release,
Manipulation turns the key,
Caught up in our grief,

Mardi Orlando

Vulnerability in exposure,
Superstition supersedes,
Hide within the borders,
Venerability left to weep.

DAMAGED
(Epileptic Daze)

Secondary life spasms
fifth dimension
detached,

Epileptic days
of short-wave shade,
Shift shapes, shift lines,
switch one of two
borrowed minds,

damage
rerouting itself.

Primary existence stirring
white haze,
attachment,

Alternate laws
set on change,
Rote memory divided,
seizure's, reminders
contained,

abstraction
of mind and state.

THE STRANGERS DAY

It is a strange day the day life turns cold,
My naked soul, unwrapped by shock,
Plunging from a cliff, from which I had not leapt,
Delving into iron gray oceans, overburdened with salt,
Cuts plumbing the core,
Burning cold like the moon in shade,
a place no human should have to brave.
But life is a strange place,
Each moment an edge, each glimpse
the prelude to a blink,
Unpredictable, all of it,
Impossible to contemplate,
Lest instability unwind your mind.
So on we walk, conceiving each moment,
as if it will all stretch out forever,
Believing good will grace our path,
anoint us with existence,
We must believe or be hopeless,
And we do,
Until that day,
When the world
turns cold.

LIFE: GAME TIME SUSPENDED

Tunnel through the pageant land,

For exposure will ensure swift hand,

To eclipse all thought, how sweet how grand,

Ensure naught for you cannot recant,

Step from one border to understand,

And infinity will be further fanned,

You've entered a world of reprimand,

Where hearts are captured by the reigning conman.

If you choose to choose not to demand,

Spin the revolver, to exit this sham,

Or patiently play and play well my man,

For escape is futile: No currency – no game plan,

Next level: No exchange, No entry, No stand,

Pivot continually within this pentagram,

Pierce the enemy where the points land,

Further access denied, please do try again.

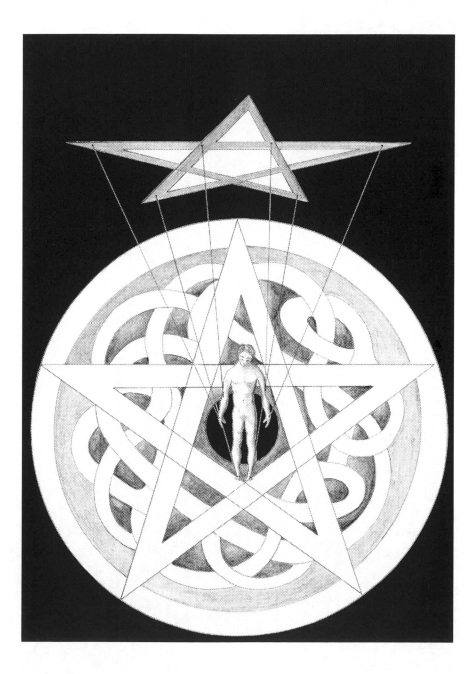

My husband suffered a sudden, massive subarachnoid brain hemorrhage. After twelve hours of waiting, the doctor took me into intensive care, pointed to an array of brain x-rays and told me he would either die; be a completely incapacitated or end up in a nursing home.

Over a four week period he was hauled between intensive care, cardiac intensive care & the high dependency unit in neurosurgery. After the tenth day he began to stroke and continued to do so for three days. He had 21 tubes administering medication. His brain was operated on nearly every day. I now understand the saying "writhing in agony". At one point, when he appeared to be lucid, he begged me to let him die. I questioned whether I wanted him to survive for him or myself. I questioned many things.

My husband, although suffering from some brain damage and resultant epilepsy, has made a remarkable recovery, and he has not ended up as the doctor suggested. I am honoured to celebrate his life.

THE WAITING ROOM

Emotional toss,
Into god's rise,
Paralyzed strikes
as the minutes pulse by,

We are the waiting-room-stains,
We are the left over cries,
Desperately seeking
the god-doctor's lies.

Hope netted in the Black,
Star-gambled sky,
The white blindfold
hurled into the abyss,
Human grief Eclipsing the mind.

Mardi Orlando

People drift in,
Thin out, all silent,
as I float on the brink,
of everything alive.

Tears, Hospital grey,
So very tired,
in these screaming seconds
when the hours have turned quiet.

The god-doctor speaks;
Titan's tides,
Apparently,
There are three ways to die.

Our left over moments
x-rayed now in black and white,
My husband's brain:
Blood filled light,
And a dozen pictures
to prove the god-doctor right.

Each increment of waiting
Weighing our unfinished lives,
In these instant hours
of sprawling time.

Sculpting the scriptures
of how we've lived our lives,
Time drifts in,
Thins out,
Strangely quiet.

The Life Expectancy of Wind

In this ceaseless,
Gambled, Starless night,
Why is it so still,
hovering on the edge,
of someone else's life?

Eyes closed,
Prayers tossed,
Into god's rise,
Heads, Tails, Heads,
Life, Shadow, Light.

THE TRAVELING RAIN

Its quiet outside,
I was hoping for rain,
The trees stand so still,
No wind breathes my name,
I have called,
It won't come,
So typically unbrave,
So, I sit and I wait
For the unwelcome
escape.
Its quiet inside,
My thoughts lost amongst days,
So many sweet tears fall,
In the traveling rain.
Even in slumber,
All movement has slowed,
Blood-blacked-out heart,
This grief grandly owned,
Moments so measured,
By the infinite tow,
Heaving and pulling,
Yet remaining just so.
Managing somehow,
The world's held away,
Distantly looming,
In the traveling rain.
My mind to its silence,
Naïve and afraid,

The Life Expectancy of Wind

Black calling from all things,
Won't the evening unfade?
Costs without curfews,
Darkness, blown so wide,
in this jingling jangling
jungle of mind.
I hear rain in the distance
moving further away,
I wish I could move like
The traveling rain.

THE SANDMAN SEES

Sea-rocks, singing, Luring parched hearts,
Into sea-snake skies; Waiting for earth to speak.
Out into the wild of the midnight depths,
In the deep heart of the sea's season,

A tiny voice is dying,
beyond earth's last captured breath.
Vomitus seas of iron strength
anchor baby's fragile cradle
to ride the manes of creamy foam,
as the horses ride to win,

And away the life
that sifts the silt and walks the waters
of the souls of freedom of exhaled winter,
A tattoo swirl in cursive seams,
Marking the meaning not yet comprehended,
A smudge of lead on a page of stars, rubbed out.

In waking intervals of sleeping light,
Curl your hands amongst the waves,
Eyes to darkness and ears to wind,
Earth's mail guarded by those who do not need it.

THE COOL SIDE OF DAWN

Tonight I can be a dream for you,
This night, you know, was born for two,
Seek my likeness; it falls in the brightest light,
But its being is void of life.

Oh yes, time and time you've seen my face,
In nights, limpid and calm, that can't be traced,
I have taken time from you, but have never
revealed the ultimate truth.

Oh, I sleep on the cool side of dawn,
Expressing destiny's freedom of form,
So take my essence, for it's your ego,
My time is yours but you must follow.

Yes, this night was born for two,
Weave your thoughts across my sunlit moon,
For I am that you patiently perceive,
I am simply the love of a dream.

THE MOON NURSERY

The Moon Nursery,
knocks three times,
The Ivory Grams of her
empty womb,
weigh the cold of
lucent grief:
Lustrous moonstones-
Surrendered seed,
Sterile pits
cast into an open sea,
Unleashed, I hear her scream,
Her voice is me.

Her crescent soul,
A cradle, Tired
of the holding light:
Succour to
a salt-tree child,
Soured milk from undrawn brine.
The silver scales
amassing phases
of all those moon-cycles
left behind,
Tombstones yet of unmade life,
All selves that are not mine.

The Life Expectancy of Wind

I am not a wife,
His wife is me,
Her waste falling
from my indelible needs,
The ivory stars
of unguarded wounds
Spinning ice from
frozen grief,
As silk–cold stones
of creed unthawed,
Weigh deals cast from
Ancient deeds, Evolution
and Primal greed.

Night tide against
the green sea-wall,
Race with darkness as
revelations form,
Watching relatives
bearing child-joy
to grow themselves a history,
Resentment breeding her,
into me
Until the cold stone weight
of truth concedes,
the infertile bed for
misplaced dreams,

For lies to lives don't matter
in the end from me,
The family tree stops here.

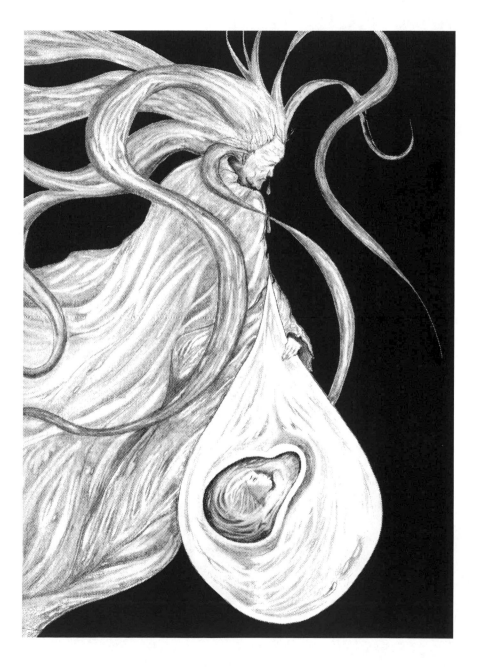

STORMING

Cockatoos screech, Night black, Crying,

Against purple pleated skies, that yawn after clouds,

claustrophobic and full with the thunder of the captured day,

Filling the air with humid warning, as

Summer's silky wind turns to sweat,

Unfastening Goliath's silent tomb, stirring

Pungent smells of earth and death

raised from steaming minds that tear us

from our dreams, and bend us from our kind,

Whose silver words: Nails of gun grey rain,

Defile god's corpse, Curse all light, Imprison shame,

Inhaling the stench of drowning mercy,

Forcing us, in rival rage, to long for open skies

above the reign of pressure obscuring the burning stars,

Where even barometers cannot disguise

the oppressed and swollen clouds,

Overburdened and overwhelmed,

The sky so gravely bruised, The winds,

Perpetually off course, as so the weather vane spins

to find true north, until, in tempest warning, with no breath left at all,

The dying air must wane, preparing once again, to cry,

as the cockatoo's screech this black night.

SULPHUR WINGS OF STOLEN MINDS

Sulphur wings, acrid, curling, stealing
the light of stolen minds
Cinder flakes of twisting rage, sealing
the migraine skies,
Reigns, wrenched, by fists of night, crushing
the writhing wronged,
Fits of blame suffocating the lost and stifling
the innocuous throngs,
Long days in hell firing the mind that seethes
from sun to earth,
The scolded mother of the smothered child,
the sons of death
from birth.

Lay brittle before the light, offer your ashes
to the sculptured rings,
My secrets are tired of ribbons and the flavoured
speeches of opal minds,
Grate curdled truth amongst us: Snow, stale and
stained by life,
concealing the light
of broken lives.

Crack fury's mould open, treacle-black
blood released,
Into day's tryst, into horizon's divide,
Into days deceased,
Into the nights

The Life Expectancy of Wind

of the cowering blind,
Headache cowled, drugged by
sleeping minds,
betwixt open and closed eyes, where fires
cannot burn us,
and escaping sulphur wings
take flight.

WOVEN LIFE
(The Making of my Net)

Gazing over waters
Blue with sky and wisdom, Green
with change and choice
I twist the twine and wait my turn,
to cast my crisscrossed web, into
the shadowy unknown, into
words unsaid. Unfurled,
across the aquatic shield,
Enchanted, Spread, I reel thoughts
and watch the threads etch
the sunrise surface into latticed
diamonds, that glint of broken sun,
and the prescience of idle's eye:
The world below, its kingdom's smile, god
growing inside Apollo's heart,
Wonder growing up.
My net, now plunging, through depths like ranks,
Into fathoms that hint of good and beauty,
Into worlds that reign with honour,
Its crystal chain strung with cockles,
To catch the cognitive heart, cogent in its quest,
Cast out to sea, my thoughts take leave
to capture golden dreams, of fruits
too luscious to conceive, of tastes
that bend the mind to light, that cleanse the
soul with liquid sweet enough to baptize
the cruelness of the salted seas in seasons Purple
with pity and distance, and cold with winter and sleep,
Desperate for the salubrious joy of essence and
the lift of kindness which I shall catch with
The tightening of my net.

OPAL RAIN

Gravestones shine
like Moonstones
in the opal rain,
as cobweb memories
Glisten;
spinning further
and further away,
The storm-blue sky,
A curtain closed
on this very quiet day,
As transparent cries
of two-shield light,
reflect my silent pain,
To stand so still,
Just wait with time,
Defies my heart's
thunderstorm parade,
Yet filaments
of fragility
bless this last refrain,
As missing words,
Fall like tears
In the opal rain,
The only promise
in this grief:
Is that everything
must change.

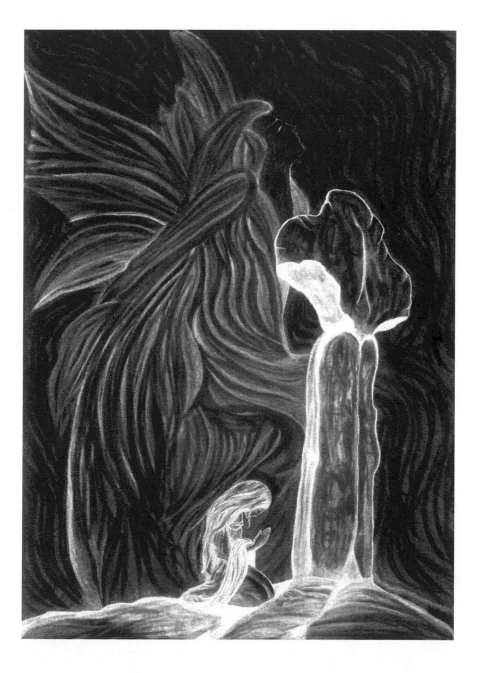

IV

THE MEASURE OF TOUCH

"Humanity's intangible masks,
Ghosts at a grave,
The writing of our human stories,
Our sacrificial pages."

BUTTERFLY PARK
(Away with the Butterflies)

The enigma of
Thought,
Uncanny in its
Brevity,
Where music loops its
Pledge,
Around simple
Sanity,
The sway of
Reflection,
Generous in
Banality,
Crescendos out across the
Ledge,
Shattering all
Reality,
Soaring notes of
Syncopation:
The flight of
Fallibility,
The strike of insanity's
Hammer-hawk wedge,
Unbending in its
Finality.
The treble clef curls its
Tail,
Around the bars of your

The Life Expectancy of Wind

Mentality,
Vision twists behind the
Shoulder's edge,
Butterfly Park dreams its own
Morality.

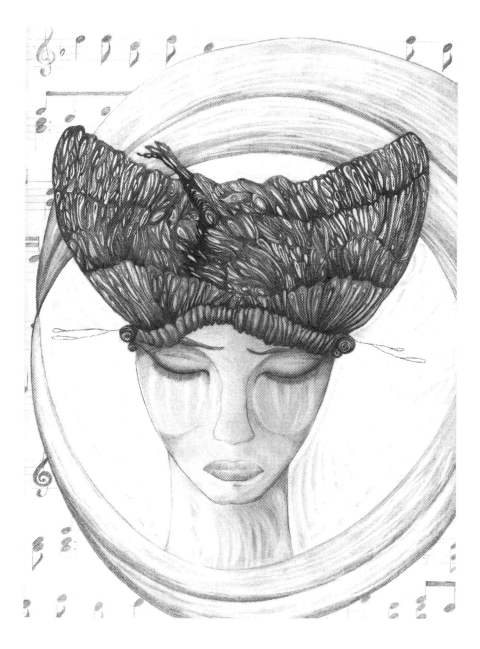

ABSALOM'S SWORD

Bend beneath the bony greed
of Absalom's sword,
Limbo light with a juggler's skill,
between good and evil:

Twain twisted like worsted yarn,
Balanced, yet compromised,
The eye's focus distracted,
wounded by the falling compass.

In gardens that equalise
the score of darkness
with suns and moons and warning;
Who will serve as your spies?

Escape to the middle,
Look grey and straight at the centre of being,
Versions of knowledge, hedging truth,
contorted by life and thrown by subversion
and acts of malevolence that sway your stars,
qualifying gratuitous journeys taken,
Hunger for the entirety.

Crime upon crime,
Consequences fumbled by fury,
Monuments erected over false opportunities,
In mourning, the grief of possession and loss to come
that white-sky promises cannot concede:
A pillar named in place of a son.

Mardi Orlando

Presence in absence, a pierced heart,
Three spears unite to call
the cardinal number,
Of one and one and one.

VERTICAL BLEEDING

Vultures course the fragrance of new minds,
Eyes like dragons, dripping lies from salivary glands
that moisten hunger for future forages
into the careful lives of others.

Hearts bursting their volcanic seams,
Circling for young blood in aberrant desire,
Need bleeding the rational, the master and thief intertwined,
For over-welcomed fools who foolishly find,
You cannot right the hand of disbelief,
When all disappear just before the goodbye.

The scavengers feed from the naked children
running the path away from hell
and still want more,

Insatiable salacious needs seeded in the shadowed
eyes of Picasso's stare, mercurial thoughts,
advanced in measure, undermining truth or dare.

They hunt to draw forecast force and form new minds,
To challenge the lives of auspicious minders,
and rupture the stasis of those to whom tend toward
totalitarian tenure,
To breed recalcitrant progeny to forage for themselves.

HOUSE OF CARDS

Birthday born
Of simple sums,
His reaching hand
Grasping none,

Marked alone,
Like a single card,
Split the deck for
The ace of hearts,

Doubling up
For the dual of life,
Two pair holding,
Second call twice,

Lay out triplets,
A magnificent strike,
Third hand lucky
And versa vice,

Boxed inside this
House of cards,
A worthless temple
Of endless starts,

Club's flush hand
Heart beat drums,
The circle closed:
The last lost sum.

OBSESSIONS

Tantalising obsessions:
The tainted spirit.
Your laudable questions,
Are answers forthcoming,
Green snakes of fire
twist beneath the breadth of life,
The tensions of longing,
Incased in time.
The impatience of a child,
And imperfections of humanity,
Whirl themselves toward your vanity.
Lest we judge you by ourselves,
Your our obsession,
And that is obsession itself.

THE MAN WITH NO UMBRELLA

Charcoal streets, heavy with rain,
Smudge the lanes of truth.
Reminders flood, Swelling tides,
Rousing dormant youth,

Air so thick with poignant calm,
The leaden sky stops breathing.
The heavy hold of untossed clouds,
Arch, Weighty with time seething,

Empty walls of peeling paint,
The reasons lost to choice,
Dim long days of silent waiting,
and that forever aching voice,

Smudged glass out and cracked glass in,
Sweaty wind then swirls its call:
Step outside to the charcoal streets,
Where the sky is just waiting to fall,

Slip across the lane's glossy pavers,
Trick the night that dwells unto her,
Under the dark hood of no reclaim,
Treads the man with no umbrella.

THE SOUNDLESS CHILD
(Neville's Storm)

He swings the sigh
of a deaf man's eye,
Unvoiced words of
the world inside,

His words slumber
As my words drown,
Unused cries
in this soundproof house,

Anchored in stillness,
Where echoes can't touch,
The backs of you audience,
Your inaudible judge,

Howl loud like thunder,
Splinter static fear,
Arouse the dormant storm,
No one wants to hear:

A formidable hush,
In the crescendo of life,
For un-fortune or fortune,
You are the soundless child.

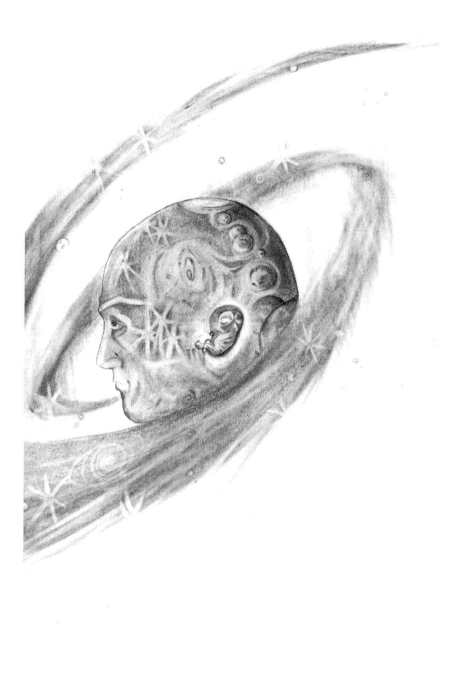

RUNNING INTO THE WIND

Awakened by wisdom,
White light burns my skin,
My senses forcibly flooded,
I am running into the wind,

My vision is clouded,
Atoned tears sting,
Wind blasts my body,
I'm flying without wings,

Then instant and cruel,
I am falling from great heights,
From bleached ivory skies,
I plunge into infinite light,

The swell of the ocean
Rushes my thoughts,
Churning and heavy,
I'm hopelessly caught,

Every breath of its currents,
Whispers my course,
Unhurried it swells:
'What's due in life's court',

Then all becomes still,
Gentle and kind,
My senses stretch open and
I'm touching lost time,

The weight of earth-life
Tears away like a skin,
And my earthbound essence
Runs on into the wind.

POWDER FOR POPPY

Line up, line up,
Line up till dawn,
Swipe the diamond card,
Like credit for porn,
Line up, line up,
Line it up for the night,
White-line-fever,
Promises far more than life.
Line up, line up,
Razor scrapes the glass,
Powder for Poppy:
Inhale the stars.

Line up, line up,
A clown for the ring?
Line up, line up,
For purity's new meaning,
White-line-fever
Has everyone scheming,
Buy all his promises
Trade your sex for his stealing.
Mirror and corner,
Razor scrapes the glass,
Powder for Poppy:
Inhale the stars.

THE WINGS OF RAIN

Fingers of the
warlord light,
Prod prescience
of nomad might
unto which I succumb,
to venture into,
to become.

Lifted by
the wings of rain
And beckoned by
the thunder,
I follow in
to your terrain,
To wade amongst
elemental wonder,

Where stars
are your crisscrossed crib,
Where planes of time
converge with mine
Where transience
is infinite and
Infinity is divine.

TO EXCESS

Desire swirls, curling for more,
As liquid light opens the kaleidoscope door,
Colours free-falling backward,
Sinking back into the mind,
Divining the dark depths of the human core.

The purity of pleasure courting toxic delight,
Running too far forward in this fall-forward light,
Dive from the board that dissolves all that's all,
unfaithful heart's Crisscrossed fall,
Promises trailing behind.

Strange words evolving
before drowning themselves,
Sharing the idol that avails itself,
To our virtue, our right, our preemptive strike
On those who judge symptoms as selves.

Desire's descent still curls for the core,
And more…
Consumption consuming the truth,
Cravings for numbness will refuse reproof,
As liquid light closes the kaleidoscope door.

ORPHAN SPIRIT

Yes that seven winged tattoo,
Of red and green and blue,
Like inky memories,
Will forever stain your past.

For you are a child,
A child lost to honesty,
And I sense your lonely cries are tired,
As your past exhausts all modesty,

Your congeries of questions,
Fights your future, defeating lessons,
You know you must save your weary longings,
For tomorrow only brings more lies.

Tempt not those single-eyed serpents,
Who judge life with sacrificial service,
For they think not of the tired child,
Whose only gift is life.

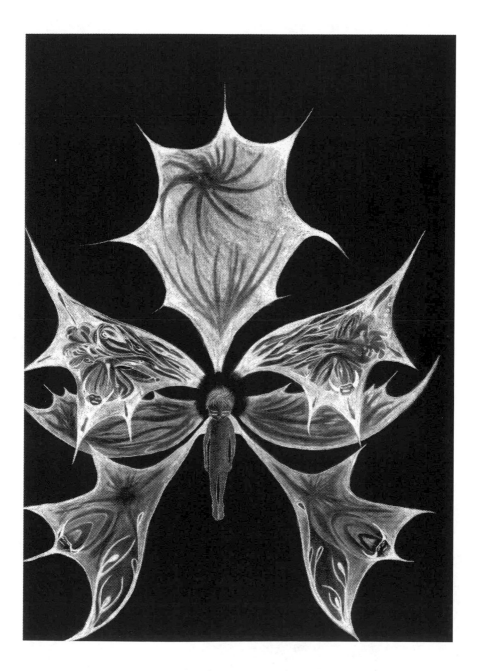

HOW LONG ONE LIFE?

Slumber across infinity,
Eternity in flight,
Stumble up to certainty,
This moment, this second, this life:

Hands stretch out to feel the dark
As thoughts retract like frozen time,
To touch the black hole of wonderland
Which stretches out our wasteland lies.

Internal twist of a winded clock
That has long run out of time,
Coiled circles of simple earth,
Listen for the silent chime:

Marked words stutter black and blind,
Staccato shivers of pent up time,
Coldness standing so very still
On this side of the line.

Watch the wall of broken bricks,
From point to point we walk the line,
On this side of infinity,
Hesitate and die:

Endless fall into second thoughts,
Blinking blackness, wasting time,
Pendulum swings to count us down,
Suspended threads of immeasurable life.

Falling from this blue-green globe,
Eternity in flight,
Instant such a very fine line,
One moment, one second, one life.

WEEDS

Creeping into our blood-lined lives,
Weeds tangle our every thought,
Of perpetuity and performance,
To court our lonely course.

Weaving arms of supple strength,
Anxiety's all round flight,
Twisting the fear inside our chests,
Fancy-free-face faked like life.

How far fight the grit and grand,
And those cries deep down, so dark?
The bold and beautiful and their icy cold hands,
Creeping like weeds to remake your heart?

For that dark mess crawls just awaiting the time,
Awakened only when it's all too late,
Realizing innocence was a most beauticious line,
Look over your shoulder the tsunami's awake.

Weeds are these which tempt and tease,
Castrate laughter with simple ease,
They are future frustrations and past remonstrations,
They are other people's thoughts derived from other people's needs.

We accept all these worn confusions,
Tangled as we are, and tired without means,
To mark the same life-notched trail,
To crawl, then walk, then kneel.

Such blood streaked hands mould our children,
Who grow to shoulder our remorse,
Lost decisions become simple acquiescence,
As our remade hearts course our lonely court.

WAVE GOODBYE

So here we are, you and I,
Human strands in stranded time,
A corner-stone and cut-glass tine,
The world surrounds us: The intangible climb.
Bubbles burst around us;
Swirls of incandescent flame,
It seems so quiet to make all this fuss,
What did the shaman say?
Memory sees his silver locks
shake from side to side,
His brown creased brow, his ancient hands
and narrowing dark eyes,
His head bowed low in silent prayer
On our life's longest day,
For we watched the promise-ribbon twirl away,
In his whispered words: 'What a shame, what a shame'.
We felt the quiet shiver of cold restraint
shoot through the warmth, a quite pitiless pain,
Life's pretty pattern all blurred and stained,
Lost plans spiraling in the white whirlpool of day.
Colours abandoned us like windswept sands,
Relinquished time by god's green hands,
Unrequited certainty in undiminished demands,
Watching the slow vanishing is surely to understand?
So here we are, you and I,
Climbed as high as we could climb,
Cast your loss into the fast fading light,
And remember the shaman's sad dark eyes.

THE IN-BETWEEN .I.

Walk toward the undecided;
See how still you feel,
Bend, not break, the unrequited,
Fine strokes will slant the quill.

Borrow time like Old Lang Syne,
And smile when they accost,
Try to sleep within the tender hours,
For dreams are just past loss.

Feel that strength? It's insouciance,
That only past-on life can feel,
Wondering where you are yet?
You reside in the in-between.

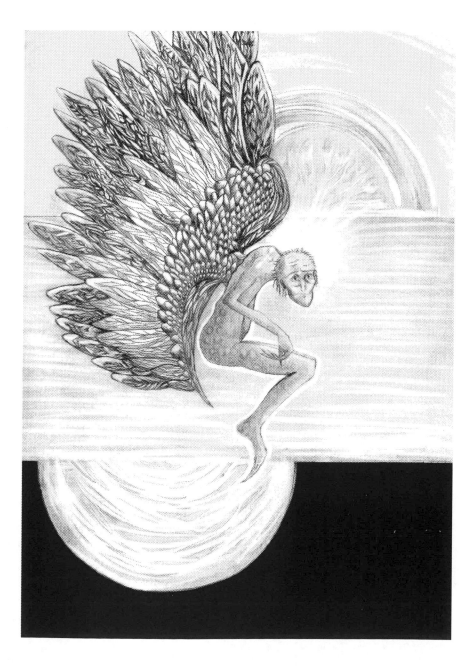

SURPRISE: IT'S OVER .II.

No bright light?
No last rushing visions?
What are you thinking now–
You are a significant omission?

Well, where are the others
After the last feelings of life?
Guess what, you're all alone now,
Even more so than with your wife.

Disbelief in what I say?
Or blind belief to human prayer?
Look around all you want.
There's nothing here you can share.

What did you think would be felt
At the moment of life ending?
A call from god; angles singing,
Acceptance in His realm: Pending?

Humour me for just a moment,
Pretend you're still a being,
Did you believe that all those needs,
Would be answered when their grieving?

This is it, now my friend,
Sorry to bring you truth,
But I have been here so very long,
I guess I am your only proof.

Bet you're wondering:
'What to do now'?
Too late my friend,
Here there's no time, no power.

You were supposed to 'live life'
As a human coward.
Irony? Sure.
Very un-empowering.

But the truth is really,
I never cared much for living,
And now you've heard the facts
Of all misgiving.

Well, here's to nothingness
Just a question of mortality,
I wish I could remember what life felt like
Before human finality.

V

THIS SIDE OF SILVER

"Now this rhapsody of bitter-sweet crystallized memories,

Hangs like a low mist on the skeleton of dead trees,

And the pain within, sparkles like the last bright jewel,

The naivety of happiness known only to a fool."

SONGS FROM MAGNOLIAS

Lean into the wind and up to the clouds
as cirrus thoughts expand,
Offer affirmations up unto the sun,
Sing songs from magnolias, sing prayers from love,

Swing your golden sword in a perfect arc,
Call forth your promises that pledge your heart,
Sense symphonies swelling deep inside,
Seeking eternal sight,

Open your spirit to god's bleached sky,
Brushed by the magician's deft flourish,
Feel the intangible hands of elusive time,
Beliefs declared, Mind opened wide,

Sway your spirit, grateful, and kind,
Lay bare yourself to the six senses of eve,
Sense the colours beyond this sun,
Sing songs of magnolias, sing prayers of love.

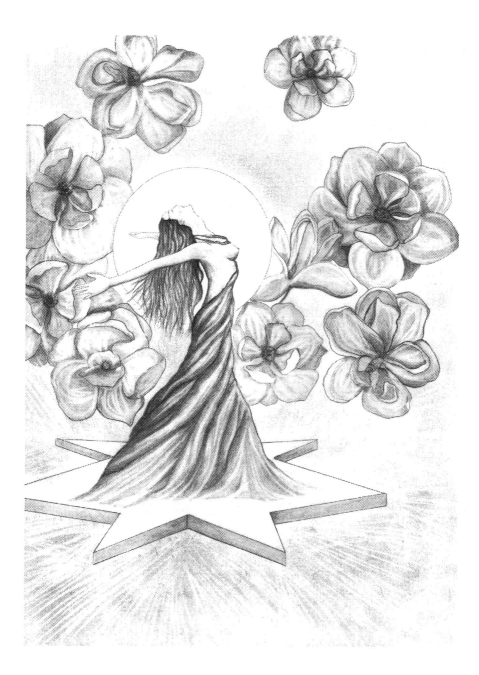

ALL WE ARE

We shift like sand:
Ghosts grown from
shifting land:
Gauzy whispers of
what once we had.
Now,
Spun stones of light,
We weigh upon
the darkness,
Night,
We wake, we sleep,
We dream, we shun,
Beating time
to climb each rung,
We beg, We sell, We buy,
Deep sighs,
Awake but sleeping;
Unopened eyes.

We must,
Raise our souls
toward the sun:
Lifted faces seeking light,
New stars to reach,
to learn new life,
To look beyond this
earthbound sight.
Unblinded by the darkness

of slighted night,
Shine your golden globes
Starlight bright,
and bend your thoughts
back toward your
Silent silver quiet
and find out all we are.

SOUL OF SNOW

Fallen grapes on
Frosted ground,
Perfect passion of purity.
Shall not the pearl of thought,
be crushed;
Or the rose of
Bliss,
Unfold brown and dry.
Let spilt wine,
like drops of blood,
Smear milky flesh;
Pouted lips,
Waiting,
Fresh skin,
Dusted with talcum,
Touched with scent,
Purity,
of forgiveness,
only passions of the heart.
Let not
my wonder
escape me
replaced with
the coolness of age,
Be a man,
for what is now;
Open the bud of youth,
warm me, touch me,
Skin to skin,
Rose to rose,
Pearl to pearl.

OPPORTUNITIES

Warm words spread,
like an eagle's wings,
within your souls,
Transient peace,
shall test these mortals,
For we, are opportunities,
which fly and skim
through Fall,
We hum and sing,
and dance through Spring,
We are forgiveness;
an open door,
We are that which look for virtue,
beyond recognition of a King,
And are to those
of which we bring,
completely without flaw,
The seasoned hopes,
of human spirit;
The coolest sigh,
of Summer nights;
And in the Winter,
a guiding light.

AWAKENING

Whisper to me
in your most cherished sleep,
I shall hear,
I pray the Lord to keep.
Unwind my love,
like strands of gold,
My heart is yours,
a cocoon to unfold.
I know your hopes
fray with every fear,
Shall I stay,
shall I hear?
But if you hold my soft flesh
and sing to me,
Those sincere notes
of memory,
Your quiet whispers
I shall hear,
And in waking,
I shall break the spell of fear,
Then the silver link
which fortifies our souls,
Will turn to golden rings,
our loves spring to behold,
So wake me
in your most cherished sleep,
I will wait
and pray the Lord to keep.

TEARS TO RAINBOWS

Allow your tears to flow,
down the rainbow,
of your dispirited dreams,

Let them fall,
like crystal balls,
Of sparkling memories,

For I will catch them
at the end of the earth,
And turn them into me,

And your secrets and sorrows
will be my tomorrow,
For together we will believe.

THE LEDGE

Rock me to the edge of the world my love,
Rock me gently.
I have seen enough of the world my love,
And it has seen enough of me,
evidently.

Lead me, slowly lead me, up the face of the mountain my love,
I feel alone.
Look into my eyes: the shadows of my spirit,
For here destiny shall pivot.

Still lead me, so carefully my love, lead me to the edge,
So I may watch,
The crashing white surf shattering below,
Upon the sharpest rocks.

My love, help me, please see what I can see, it is so simple,
It feels so free,
Now my love, we can see together,
Join me at the edge of the world, step closer.

Hold my hand, now we shall leave the edge of our world together,
To join those crashing waves and rocks,
To join a world of divine peace,
Now my love let us descend.

LOVE ME, LOVE ME, LOVE ME

Love me, love me,
love me more,
Bend with me
as the sea calls forth
Swirl around me,
a whirlpool shawl,
Pull me into your tides
with a whispered call,

Hands like seaweed,
swimming still,
Caressing the sea-bed,
swaying skill,
Swindling time,
swallowing sound,
Sinking deeply into
dynasty's sandy mount...

Love me, love me
love me more,
Rise with me
as the sea calls forth,
Slide me into
that swelling warmth,
Surrender me to
the ebbing storm,

The Life Expectancy of Wind

Swing with pulse
and push in blind,
Where waterfalls cascade
deep inside,
And ecstasy blinds
like a salt-sting smile,
boundless desire in an
instant of infinite time.

ODE TO YOU .I.
To sleep in your world

This morning when I woke,
I watched you as you slept
Innocent and vulnerable;
Beautifully wrapped up
In my bed.
I wondered if you dreamt
As sweetly as it seemed,
I watched you wake,
Soft and hazy;
Diffused like early
morning light.
In the new world: today,
You opened your
Dark brown eyes,
To welcome me
By stretching coyly,
How can a man be
So beautiful a sight.
A sniff, a yawn,
A hand touching my face,
Eyelashes flutter,
Not yet truly awake.
A moment so simple
So still, so quiet,
My contentment glows in return,
As you,
My somnambulant friend,
Curl up tightly
To drift into dreams again.

ODE TO YOU .II.
To wake in mine

A sleeping child,
The only innocence a man reveals,
In gentleness of mind, my love,
Are you only when you sleep.
For when you wake,
You see too much,
You know too much,
You feel too much,
And you can give little,
For there is little left.
Does not the reality of the world
Compel you to a warmer heart;
My heart?
I seem to want forever,
Hoping you shall wake
The way you sleep.
My sleeping child,
Filled with peace,
Is a man I shall never know.
How I long for your
Permanent solace,
And your much needed
Peace of soul.

THE PUZZLE TREE

Wind around
the arches
of the Puzzle Tree,
like me,
Curl up inside
your thoughts
and see what you can see,
Climb the rungs
of branch to branch:
Bridge the boughs
of all obscurity,
Your high enough
but there is more
so bind your bravery
and rise on up
to the very top
where you'll finally
believe you're free,
Now you need
to find out how
to make your final plea:
For don't forget
you've wound yourself
around a Puzzle Tree,
like me.

BREAKING TIDES

Brown eyes,
breaking tides:
The cradle-song
in my soul
just shines,
Simple smile and
laughter like
the quiet golden
evening light.
Your gentle whisper
swings sweetness past
that ever-mending hole,
your safe embrace
and sure reply
calm the tears
of years gone by,
and pleasure swells
deep inside;
a place,
in remembrance,
I used to hide,
For since, your gold
has weighted me,
to a place
I finally want to be,
I can ascend;
from lost dignity;
and awaken my heart
to peace.

INTO THE BREEZE

Patiently waiting for,
The sweetest reprieve,
Evicted by love,
The game we all cheat.
Today breathes enough,
For the lonely to hide,
My wrapping is moment,
My memory too tired.
Calmly replaying,
The game as I need,
But somehow just aching,
It's no relief to concede.
Heart disperses in the
Wind's drifting dust,
Protected by moments
When butterflies touch.
Distance draws nearer,
The peripheral line,
As the hourglass stands still,
With the running of time,
Twisting and turning,
I bend with the breeze,
Making the inevitable return,
To the game we all cheat.

WEDDING SONG .I.

To wish upon the universe,
Reflected in lands and streams,

To wind love amongst the stars,
And below celestial seasons dream,

To lace the threads of light and life,
Across midnight's starlit beams,

To twine our hands of wedded gold,
Around loves spinning spool of dreams,

To share our hearts in moonlight cast,
Upon these never ending seas,

To shine our souls in the galaxy's shadow,
And light the way for lovers' dreams.

LOVER'S LIGHT .II.

I dream in white and seek the light
Deep within earth's seams,

I drift in snow and sense life's flow:
I am the energy in earth's streams,

I listen for silence and wait for guidance
High amongst the moonlit beams,

And cry the colours born unto lovers
That ebb within earth's dreams.

MOONSHINE

And now you wonder
why sunsets are cold,
Why moonshine streams the dusk
and darkness takes
hold,
Why the seascape runs away
beneath your feet,
with the waters of the waves
we used to defeat,
And now when the sky
grows cloudy and dark,
you watch white caps on wedgewood waters
break with your heart,
And you long, so much,
for the warmth of the sun,
But it stands behind me
for I am the one
who has won.

COLD GREY HANDS

Whose that man
with the cold
grey hands,
That insists we
follow remorse?
White collar, Black coat:
Uniform,
To reinforce
or just force?

Stranded strains,
of sweeping pain,
Fall and fuss
our thoughts,
But I know that
this strange state,
Throws us all
off our course.

Inquisitive thinking,
Quietly sinking,
Shifting minds
Can not follow this source,
What happened to
the right to think,
And make your
'god-given' choice?

THE EDGE OF TRUTH

The edge is cursed
by boundary law,
Which feeds us all our lies,
For we believe,
that conscience strikes,
To mortalise our kind,
But truth – not virtuous mind,
Is unrehearsed,
Implicitly blind,
For until the proof
of legitimate life,
is unbound before our eyes,
We venture backward
into stagnant time,
Unable to bear its child.

THE OLD MAN

His eyes of wisdom held my hand,
He praised the children and called to hand,
The words of wonder that shook the land,
Years ago, Before 'this' man.

His light was life before time began,
His warmth was mine until earth's fine plan:
Prestige and perfume to permeate the bland,
Possibility becoming perverted and damned.

Progression and prosperity and purposeful sham,
Population and privilege and pious demand,
That let the vision of progressive man,
Tempt its tinctures and taint its clan.

He was were, And I am am,
Destined and derivative of could and can,
His light dispersed, Lost on lost man,
and left alone we cannot understand.

Long lost hope cannot return,
We can't praise the children
for they've felt our hand,
All words of wonder have now left our land,
Too many years have passed by
To reclaim 'this' man.

ONE LAST TIME

Let's go once
Around the earth,
To review
All that's seen,

From history's
Wild deluges,
To the innate
Beauty preceding,

Let's take
One more trip,
Around this earth
To course all that's been,

Take a moment
To review this life;
Drift in the
Conscious stream,

Let's go once
Around the earth,
To understand
It's lost dream,

Let's traverse
It's infinite time,
Before we
Set it free.

CARMELLA'S CLIFF
The 13 thoughts to Judgment Shine

Who is your judge?

Do you have respect for your judge? If not, is that your fault?

Does this judge have compassion for individual forms of life?

What effort was involved for the judge to get to this position? Has the judged worked hard?

Why is this person your judge?

Why is this person more capable of judging your life than you?

Should you care?

Truthfully, are they required?

If needed, can you retort, show your resources, and if not, why not?

Are you defeated?

Does this make you feel you should have acted differently
in your particular circumstances?

Does this make you feel like you have endured as well as possible?

Could you be a judge?

ANGEL'S VERSE

The Covenant begins
The cyclical curve:
Hush across time
For the first of the first
Cherub face smiles
Mother's heart bursts
First words bind them
Like angel's verse
A prayer to the Maker
Unites sky to earth
But pledged silver whispers
Spurn the spiral of worth,
Natural Law definitive -
The cyclical curve,
Time and its essence,
Humanity's curse,
the arc of life Returned:
Death meets birth
Her final words bind them
Like angel's verse.

Epilogue

Expose the expedition of expectation in the question,
where we can question without coercion,
Where religion does not lay upon the heart
like mud,
and the journey is closer to the earth
than to the sky
but wishes it were not so.

Where thoughts are washed with sugar rain,
And flavoured riddles prickle secrets
In the salted air of games played by blinking children
In the bitter winds of consternation.

Where wisdom and culture course the same river,
And reverent miles of sacred words,
Spill forward in the petals of golden roses,
Faithful only to the light.

Where those who must walk the winter,
Fall against the will of water and grey of sky,
To fight forever, for the wise of eye.

And wait,
For the white light to spread out the friends,
Who have watched our folly
in the short gusts of our existence,
to offer patience and reprieve,

For,
We are all born with the life expectancy
of wind.